THE GREYSTONE PANORAMA BOOKS

Edited by PAUL ZUCKER *and* WILLIAM HENDELSON

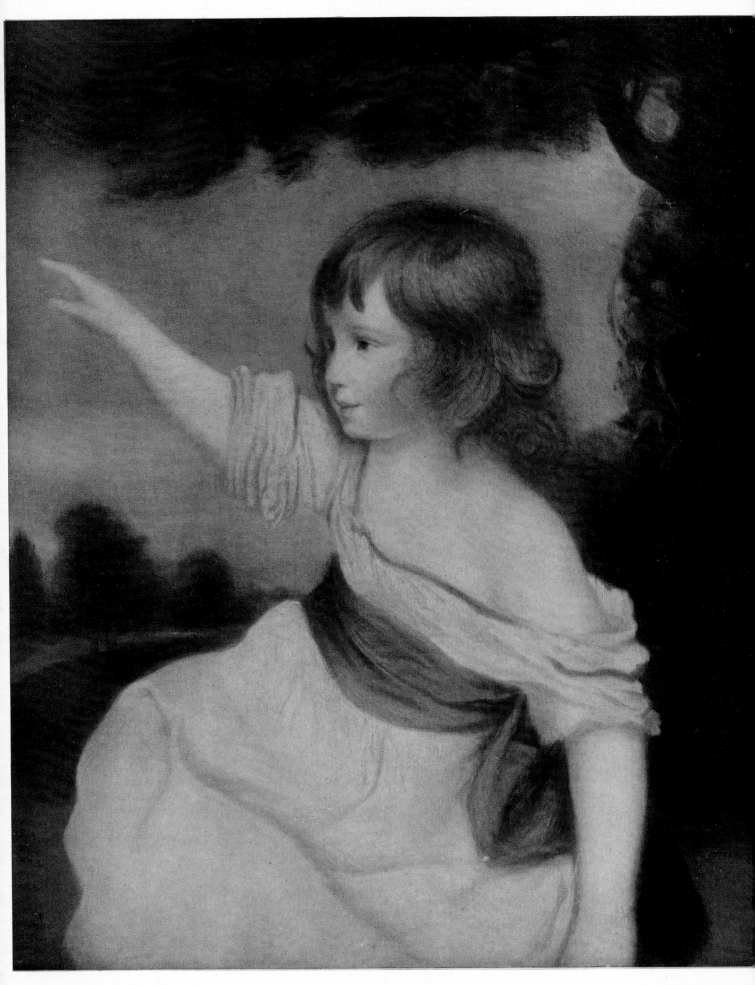

MASTER HARE

THE CHILD
IN PAINTING

BY MYRTLE B. McGRAW

THE GREYSTONE PRESS · NEW YORK

MANUFACTURED IN THE U.S.A. BY H. WOLFF, NEW YORK

TABLE OF ILLUSTRATIONS

[5]

ONLY A FEW fundamental relationships between human beings have not changed through the ages. Of these, the instinctive attitude of parent toward child is one of the most elementary: the biologically primitive feelings of parenthood have remained basically the same. But the way adults look at children, and what they see in them, has changed from generation to generation.

How do we know about the attitude toward the child as it has developed throughout history?

An old Chinese proverb says: "A picture is better than a thousand words." It may take a thousand words to make a point and still leave many things unsaid. A few strokes of the painter's brush may tell more—and tell it more eloquently—than scores of written pages.

Collected literary documents, letters, poems, legal papers, etc., in museums and libraries convey the prosaic facts about children through the ages. But a representative collection of children's portraits reveals more strikingly, through visual interpretation, how man's attitude toward the child has matured in the course of time.

Drawings and paintings of the last centuries show a great variety of conceptions. They show what adults expected children to be like. Many factors, of course, influence the artist's approach to his works: pride, social ambition, vanity of the parents, conventions of the ruling class, personal emotions and attachments, and, finally, esthetic and artistic considerations.

All have undergone radical changes from the sixteenth century to the present day, but not until the turn of this century did people at large become deeply conscious of the child, the role he plays in society, his intellectual, physical and emotional development, the problem of parent-child relationship. These have but just now been recognized in their full importance. Today the child is precious for his own sake. We no longer believe that he is solely the possession of the parents, who may do with him as they please. Nor should we forget that the relationship of the child toward his parents also changed in the course of the last few generations. It became less inhibited, more intimate, based more on friendship than on discipline.

These are new, twentieth century ideas. But within the past twenty-five years they have struck such deep roots that most Americans would refuse to believe that not so long ago animals fared better than children at the hands of the public.

The Society for the Prevention of Cruelty to Animals was founded in 1866. Some ten years later, a kind-hearted lady by the name of Wheeler became aroused over the indignities inflicted on a certain child by his foster parents. Being unable by legal procedure to remove the child, she finally brought the case to the attention of the director of the S.P.C.A. After due deliberation the Society decided that "since the child was an animal" it had the legal right to intervene.

When the public realized that lack of proper legal machinery made children animals, it belatedly got around to organizing a separate Society for the Prevention of Cruelty to Children. However insufficient for the protection of the child that measure may appear to us today, it was progress indeed in the light of the neglect and indignities he had suffered in times past.

[7]

Man has never considered precious the things which he has in abundance. Children were abundant in ancient times, so it is not surprising to learn that infanticide was practiced to some extent by the Egyptians, and even sometimes by the Greeks and Romans. Children were too numerous, too common. Today more wanted children are unborn than are born unwanted—a telling comment on our civilization.

Christianity, from the beginning, condemned infanticide and denounced it as murder. It sought to curb the cruel custom of child exposure and elimination of unwanted children. But though the early Christians established institutions, asylums, and hospitals for the physical care of these waifs, they do not seem to have been especially concerned with child welfare and training.

The Church, however, did become a stimulus for the creation of children's images indirectly, through the representation of the Christ Child, but in both Byzantine mosaics and medieval paintings, the Child was more a deity blessing the flock than a mortal child of flesh and blood. Angels or cherubs were also depicted as children. And though lacking vitality in the sense of realism, these paintings demonstrate that people were gradually beginning to regard the child's form as an object of beauty. Nevertheless, neither the painters nor the people at large were interested in children as such.

There was no attempt or intention, in paintings of the Christ Child, to represent real children. Consequently these works reveal nothing of the child life of the period. Christian art before the Renaissance idealized the form of the child to serve its religious purposes. Children as such were not deemed worthy of being immortalized on canvas because they held no important place in society.

Since the story of the birth of Christ was an important factor in teaching the Christian religion, it naturally became the inspiration of many paintings. This theme survived through the centuries and through many changes in the development of art. But this recurrence of the child in painting did not for a long time signify any progress toward a fuller understanding of the nature and meaning of childhood.

It was not until the fifteenth century—about 1450—with the advent of the Renaissance and its discovery of the individual, that the typical traits of the living child began to be depicted.

This important development took place almost at the same time in the north and south of Europe. And though the Italian painters continued to idealize their conceptions of children, the artists of the North—the Dutch and the Germans—tried to paint them as they saw them.

One should keep in mind that during the fifteenth century and early sixteenth century, a new force was making its influence felt on art— the rise of the bourgeois class. At the turn of the century the great Italian and German banking families, who were the most eminent sponsors of the art of that period, became members of the nobility. It is not surprising, therefore, that the pictures of their children should mirror the parents' social standards and ambitions.

From the middle of the sixteenth century on, a more frequent appearance of the child in painting apparently parallels a more conscious attitude toward the younger generation. This is

[8]

not to say that the lot of the child was a happy one. Discipline remained excruciatingly severe. Occasionally portraits reveal pathetic expressions of a surpressed childhood, particularly in the Netherlands and Germany; old faces on small bodies; diminutive adults posing rigidly for the artist as if they were too terrified to move a finger, afraid even to cry.

The Court atmosphere exercised its power not only over the parents of the child but also over the child itself and over the painter. From Titian to Velásquez to Van Dyck we find that the sitters are almost exclusively children of rank whose social position is strongly emphasized.

But with the seventeenth century the outlook begins to broaden. Velásquez, for instance, a master in depicting surface texture, the delicate qualities of brocades and lace, of skin and hair, also displayed a deep understanding and sympathy for his youthful subjects.

Sympathetic emotions, naturally, become most obvious when the artist paints his own child. In his famous painting of his two sons, Rubens expressed his deep love and his proud ambitions for their future. Rembrandt painting his son Titus conveys to us the whole personality of the child with the profound understanding of a father.

Generally the Dutch masters of the seventeenth century, unlike their Italian and Flemish contemporaries, were spokesmen of the bourgeois world and all it stood for. In them the social ambitions of the Court painters were not present.

Though the eighteenth century brought with it some improvement in the condition of chil-

dren, the basic attitude toward them remained a utilitarian one, and this was even more true of the nineteenth century, when children became a most welcome supply of labor for the man-hungry factories of the Industrial Revolution. The child as a factor in industrial production introduced a distinctive social concept. The gap between the classes had widened.

At the same time that Gainsborough, Romney, and Reynolds were producing portraits of the aristocracy expressing the sweet innocence of childhood, children of the less favored classes were put to work in the mills at the tender age of six. For older children to work sixteen hours a day, six days a week, was not uncommon.

While some French painters were busy painting the heads of young girls with sickening sentimentality, France still faced the problem of protecting children from such unspeakable indignities as serving as beggars for depraved adults.

Thus one should never forget that it is only the bright side of children's life which is reflected in the paintings of this period. Only in the copper engravings by William Hogarth (1697-1764) are the social problems of the unprotected child portrayed.

During the eighteenth century, France and England took the lead as centers of art. This shift of locality automatically brought with it a change in the general atmosphere of painting. French painters did not show children against a nursery background but preferred the salon or the dainty scenery of the Court parks. It was the French painters who first dared to impart erotic qualities to images of children. The

English painters, on the other hand, painted much younger children. Where the French did too little, the English did almost too much in emphasizing the child in their sitters. Sweetness and delicacy are the qualities most stressed. Social distinction of the parents is taken for granted and need therefore not be accentuated. If the Dutch child of the seventeenth century impresses us as part of a still life, the English child of the eighteenth century may be said to be part of a landscape.

Interrupting the historical review, let us try to discover the essence of painting children. Always, it will be generally agreed, we are most affected by those pictures which succeed in capturing a moment, a fleeting expression, a quick movement. It is not enough to catch the physical differences between adult and child, between maturity and immaturity; it is not enough to bring out the child's fresh, tender skin texture, the delicate quality of his hair, the clear bluish white of his eyes. A painter must not only do all of that, he must have a sympathetic understanding of the spirit of childhood. For childhood is a process of continuous change.

The impressionists in the last third of the nineteenth century were therefore especially successful in portraying children. Their technique introduced a way of suggesting action without having to catch all the details which the more literary styles required. The paintings of Renoir are a notable example of an artist making use of the new impact of impression. Mary Cassatt, who worked in close proximity to the French impressionists, may perhaps be regarded as his American counterpart. When she paints children and mothers there is no parental domination but a spirit of understanding between them. The contrast to the rigid little figures of the sixteenth and seventeenth centuries who were posing for the artists in mortal terror is extreme.

Today art has reached an unprecedented level of importance and appreciation in the cultural pattern of America. No longer must an American look for the signature on a painting before feeling free to express his like or dislike; no longer is he impressed by the art collection of a great financier merely because so many millions have been spent on it. Within a quarter of a century we have lived to witness a great metamorphosis in the attitude of Americans to the fine arts, and particularly to painting. The teaching of art has become an important factor in our educational system. Appreciation, born of familiarity and understanding, spreads and progresses today throughout this country with increasing vitality.

BIOGRAPHICAL NOTES ON THE ARTISTS WHOSE PICTURES ARE REPRESENTED

Joseph Badger, American School, born 1708, Charlestown, N. H.; died 1765, Charlestown, N. H. Originally a sign and house painter, became portrait painter.

MAIN WORKS: Portraits of John Adams, Thomas Cushing.

George W. Bellows, American School, born 1882, Columbus, Ohio; died 1925, New York. Landscapes. Daily life. Portraits.

MAIN WORKS: Up the River. North River. Polo Game. Men of the Docks. Emma and Her Children. Numerous portraits of his daughter Jean and the artist's mother.

Sandro Botticelli, Florentine Renaissance School, born 1444, Florence; died 1510, Florence. Mythological and religious paintings. Portraits.

MAIN WORKS: Spring. The Birth of Venus. The Calumny of Apelles. Pallas and the Centaur. The Magnificat. Madonna of the Pomegranate. Frescoes in the Sistine Chapel of the Vatican, Rome. Giuliano de' Medici. Drawings illustrating Dante's Divine Comedy.

Agnolo Bronzino, Florentine Renaissance School, born 1502, Monticello near Florence; died 1572, Florence. Religious and mythological paintings. Portraits.

MAIN WORKS: Cosimo de' Medici. Eleonora of Toledo.

Rosalba Giovanna Carriera, Venetian School, born 1675, Venice; died 1757, Venice. Portraits (especially pastels). Miniatures. Among her portraits, Louis XV of France and many leading personalities of European courts.

Mary Cassatt, American School, born 1845, Pittsburgh, Pa.; died 1926, Mesnil-Théribus, Oise. Painter, pastelist, etcher.

MAIN WORKS: The Young Mother. Young Mother Sewing. Mother and Child. The Toilet. Murals: Modern Women.

Paul Cézanne, French Impressionist and Post-Impressionist Schools, born 1839, Aix en Provence; died 1906, Aix en Provence. Landscapes. Still lifes. Nudes. Portraits.

MAIN WORKS: Forest of Chantilly. Mont Saint Victoire. L'Estaque. The Road. Still lifes with apples. The Card Players. The Bathers. Portraits of His Father, Geoffroys, Vollard. Self-portraits.

Jean-Baptiste Siméon Chardin, French School, born 1699, Paris; died 1779, Paris. Genre. Portraits.

MAIN WORKS: The Buffet. Le Bénédicité. Supplies for Lunch. Young Woman Knitting. Kitchen-interiors. Self-portrait.

François Clouet, French School, born before 1522, Tours; died 1572, Paris. Portraits.

MAIN WORKS: Portraits of the French Kings Henry II, Francis II, Charles IX.

Jean Baptiste Camille Corot, French Barbizon School, born 1796, Paris; died 1875, Paris. Landscapes. Figures. Portraits.

MAIN WORKS: Ville D'Avray. Albi. The Lake. The Alley. Dance of the Nymphs. The Fisherman's Hut. Woman with Water Jar. The Toilet. Young Girl. Interrupted Reading. Self-portrait. Rosa Bonheur as a Child. Portrait of His Sister.

Jacques Louis David, French School, born 1748, Paris; died 1825, Brussels. Historical and allegorical paintings. Portraits.

MAIN WORKS: Oath of the Horatii. The Grief of Andromache. Rape of the Sabines. Coronation in Notre Dame. Distribution of the Eagles. Death of Marat. Mme. Récamier. Mlle. Charlotte Du Val D'Ognes.

Albrecht Dürer, German School, born 1471, Nuremberg; died 1528, Nuremberg. Religious and allegorical paintings and engravings. Portraits. Writings on art.

MAIN WORKS: Adam and Eve. Feast of Rose Garlands. Martyrdom of the Ten Thousand. Four Preachers. Portraits of Hans Imhoff, Hieronymus Holzschuher.

GRAPHIC MAIN WORKS: The Knight. Melancholia. St. Jerome in His Study. Series: Great Passion. The Life of the Virgin.

Jean Honoré Fragonard, French School, born 1732, Grasse; died 1806, Paris. Allegorical paintings. Comedies of manners. Portraits.

MAIN WORKS: The Swing. Fountain of Love. The Music Lesson. Series of panels: Romance of Love and Youth.

Francia, Il (Francesco Raibolini), Bolognese Renaissance School, born 1450, Bologna; died 1517, Bologna. Painter, goldsmith, medalist.

MAIN WORKS: Madonna Enthroned with Saints. Madonna of the Rose Garden. Crucifixion. Assumption.

Thomas Gainsborough, English School, born 1727, Sudbury, Suffolk; died 1788, London. Landscapes. Portraits.

MAIN WORKS: The Morning Walk. The Watering Place. Romantic Landscape. The Blue Boy. Mrs. Siddons. Mrs. Sheridan. Mrs. Tennant. Duchess of Devonshire.

Hugo van der Goes, Flemish School, about 1440-1482, *fl.* Ghent, Brussels. Religious paintings.

MAIN WORKS: Portinari Altar. The Fall of Man. Portrait of a Man.

Francisco José de Goya y Lucientes, Spanish School, born 1746, Fuendetodos, Aragon; died 1828, Bordeaux. Painter, etcher and designer, in latter fields also satirist. Religious and historical paintings. Genre. Portraits.

MAIN WORKS: Life of St. Anthony (frescoes). The Milkman. Maja, clad and nude. Portraits of his wife. Charles IV. Charles IV with His Family. Duchess of Alva. Etchings: Series of The Caprices, The Disasters of the War, The Bullfights.

Ambrosius Holbein, German School, about 1494-1519, *fl.* Augsburg, Basel. Portraits. Book illustrations.

Hans Holbein the Younger, German School, born 1497, Augsburg; died 1543, London. Religious paintings. Portraits.

MAIN WORKS: Murals in Lucerne and Bâle, Switzerland. Madonna of Burgomaster Meyer. The Triumph of Wealth and Poverty. Portraits of George Gysse, Sir Thomas More, Erasmus, Henry VIII. Famous drawings in Windsor Castle.

WOODCARVINGS: Dance of Death. Series of the Old Testament.

Frans Hals, Dutch School, born 1580, Antwerp; died 1666, Harlem. Genre paintings. Portraits. Portrait-groups.

MAIN WORKS: The Merry Company. Hille-Bobbe. A Youth with a Lute. The Smoker. Laughing Cavalier. Banquet of the Officers of St. George's Shooting Company.

Louis Lang, American School, born 1814, Waldsee, Württemberg, Germany; died 1893, New York. Figures. Portraits.

MAIN WORKS: Old Mill at Greenwich, Connecticut. Cinderella. Romeo and Juliet.

Sir Thomas Lawrence, English School, born 1769, Bristol; died 1830, London. Portraits.

MAIN WORKS: Miss Farren. Mrs. Siddons. The Children of the Marquis of Londonderry. The Calmady Children. Pinkie. Lord and Lady Lyndhurst. Benjamin West. Pope Pius IV. Cardinal Gonsalvi.

Edouard Manet, French Impressionist School, born 1832, Paris; died 1883, Paris. Landscapes. Scenes from modern life. Still life. Portraits. Book illustration.

MAIN WORKS: Argenteuil. Breakfast on the Grass. The Opera Ball. Bar at Folies-Bergère. Shooting of Maximilian. Dead Toreador. Olympia. Boy with a Sword. Henri Rochefort. Emile Zola. Antonin Proust.

William Page, American School, born 1811, Albany, N. Y.; died 1885, Tottenville, Staten Island, N. Y. Historical paintings. Portraits.

MAIN WORKS: Farragut at the Battle of Mobile. The Young Merchants. Portraits of John Quincy Adams and Governor Marcy.

Pablo Picasso, Spanish School, born 1881, Malaga, Spain. Painter, sculptor, illustrator of books. Scenes from circus and city life. Nudes. Cubistic compositions. Portraits.

MAIN WORKS: The Theatre Box. Beach Scene. Les Demoiselles d'Avignon. Mandolin Player. The Three Dancers. The Girl before the Mirror. Woman Ironing. Woman in White. Blue Boy. Boy with Horse. Series of Murals of Guernica.

Henry Varnum Poor, American School, born 1880, Kansas. Painter and potter. Scenes of daily life. Landscapes.

Sir Henry Raeburn, English-Scottish School, born 1756, Stockbridge, Edinburgh; died 1823, Edinburgh. Portraits and miniatures.

MAIN WORKS: Mrs. Campbell. Mrs. Robert Bell. Lord Duncan. Dr. Alexander Adam.

Raphael Sanzio, Umbrian Renaissance School, born 1483, Urbino; died 1520, Rome. Painter and architect.

MAIN WORKS: Sposalizio. Santa Cecilia. Transfiguration. Madonna del Gran Duca. Madonna del

Giardino. Sistine Madonna. Bella Gardiniera. *Cycles of frescoes:* In the Vatican: The School of Athens. Disputa. Expulsion of Heliodorus. The Miracle of Bolsena. Incendio del Borgo. In the Villa Farnesina (the Private House of the Banker Chigi): Cycles of Amor and Psyche. Drawings for tapestries.

ARCHITECTURE: One of the architects of St. Peter's. In Rome: Villa Farnesina. Villa Madama. Palazzo Vidoni. In Florence: Palazzo Pandolfini.

Rembrandt Harmensz van Rijn, Dutch School, born 1606, Leyden; died 1666, Amsterdam. Religious and mythological paintings. Landscapes. Portraits. Etchings.

MAIN WORKS: St. Paul in Prison. Simeon or The Presentation in the Temple. The Marriage of Samson. Angel Leaving Tobias. Christ at Emmaus. Jacob Blessing the Children of Joseph. The Jewish Bride. Danaë. The Rape of Proserpina. Landscape with Ruin. The Windmill. The Nightwatch. The Anatomy Lesson. The Syndics. Self-portraits. Portraits of his wives (Saskia and Hendrickje Stoffels); of his son (Titus); of his mother.

Pierre Auguste Renoir, French Impressionist School, born 1841, Limoges; died 1919, Cagnes near Nice. Landscapes. Still life. Portraits.

MAIN WORKS: Les Grands Boulevards. The Bathers. Luncheon of the Boating Party. At the Moulin de la Galette. The Ball at Montmartre. Mme. Charpentier and Her Children. Portraits of Monet, Cézanne.

Sir Joshua Reynolds, English School, born 1723, Plympton; died 1792, London. Allegorical paintings and portraits. Writings on art.

MAIN WORKS: Mrs. Siddons as Tragic Muse. Nelly O'Brien. George IV as Prince of Wales. Mrs. Sheridan as Cecilia. Miss Kitty Fisher. Garrick between Tragedy and Comedy.

Diego Rivera, Mexican School, born 1886, Guanajuato, Mexico. Mexican scenes. Mass scenes. Murals. Portraits.

MAIN WORKS: Murals in Mexico City, Chapingo, Guernavaca, San Francisco, Detroit.

George Romney, English School, born 1734, Dalton-in-Furness, Lancashire; died 1802, Kendal. Historical paintings. Portraits.

MAIN WORKS: Scene from the Tempest. The Infant Shakespeare Attended by the Passions. Milton and His Daughters. Lady Russell and Child. Lady Warwick and Her Children. Numerous portraits of Lady Hamilton, among them: Lady Hamilton as a Bacchante. Lady Hamilton and Cumberland. Lady Hamilton as Daphne.

Henri Rousseau, French Neo-Primitive School, born 1844, Laval; died 1910, Paris. Fairy tales. Scenes of daily life. Portraits.

MAIN WORKS: The Sleeping Gypsy. Jungle Scene. Family Portrait.

Peter Paul Rubens, Flemish School, born 1577, Siegen; died 1640, Antwerp. Religious and mythological paintings. Landscapes. Portraits.

MAIN WORKS: Adoration of the Magi. Elevation of the Cross. Descent from the Cross. Madonna Surrounded by Children. Perseus and Andromeda. Judgment of Paris. Venus in the Smithy of Vulcan. The Lion Hunt. Triumph of Henry IV. The Blessing of Peace. Apotheosis of William of Orange. Return from Work. Portraits of his wives (Helen Fourment and Isabella Brant); of his sons, of Ambrose Spinola. Workshop with many pupils whom he influenced.

Gerard Ter Borch, Dutch School, born 1617, Zwolle; died 1681, Deventer. Genre. Portraits.

MAIN WORKS: The Concert. Paternal Admonition. Officer Writing a Letter. The Guitar Lesson. Woman Pouring Wine. Historical painting: The Peace of Münster.

Titian (Tiziano Vecellio), Venetian Renaissance School, born 1477, Pieve di Cadoro; died 1576, Venice. Religious and mythological paintings. Portraits.

MAIN WORKS: Gypsy Madonna. Madonna with the Cherries. Madonna Pesaro. Assumption of the Virgin. Presentation of the Virgin. Pietà. The Tribute Money. The Three Ages. Sacred and Profane Love. The Worship of Venus. La Bella. Young Man with the Glove. Charles V.

Sir Anthony Van Dyck, Flemish School, born 1599, Antwerp; died 1641, Antwerp. Historical and religious paintings. Portraits.

MAIN WORKS: Crucifixion. Elevation of the Cross. Augustine in Ecstasy. Rinaldo and Armida. Portraits of the Genoese nobility, among them Doria and Grimaldi Families. Cardinal Bentivoglio. Charles I of England and His Family.

Diego Rodriguez de Silva Velásquez, Spanish School, born 1599, Sevilla; died 1660, Madrid. Historical and religious paintings. Portraits.

MAIN WORKS: The Surrender of Breda. Christ on the Cross. Christ at the Column. Coronation of the Virgin. Stag Hunt. The Forge of Vulcan. Venus with a Mirror. Numerous portraits of Philip IV, Don Baltasar Carlos, Infanta Margarita. Maids of Honor.

Marie Louise Elisabeth Vigée-LeBrun, French School, born 1755, Paris; died 1842, Paris. Portrait painter.

MAIN WORKS: Marie Antoinette. Marie Antoinette with Her Children. Lady Hamilton as a Bacchante. Mme. de Staël. Joseph Vernet. Young Girl with Flowers. Numerous portraits of herself with her daughter.

Cornelis de Vos, Flemish School, born 1585, Hulst, Flanders; died 1651, Antwerp. Historical paintings. Portraits.

MAIN WORKS: The Artist's Daughters. Portrait of a Young Lady. Mother and Children.

James Abbott McNeill Whistler, American School, born 1834, Lowell, Mass.; died 1903, London. Painter, etcher, lithographer, writer on art. Landscapes. Portraits.

MAIN WORKS: Battersea Bridge. Thames in Ice. The Ocean. Symphonies. Nocturnes. Portraits: His Mother, Rose Whistler, Carlyle, Sarasate. Etchings: Little French Series, Thames Series, First and Second Venice Series.

ILLUSTRATIONS

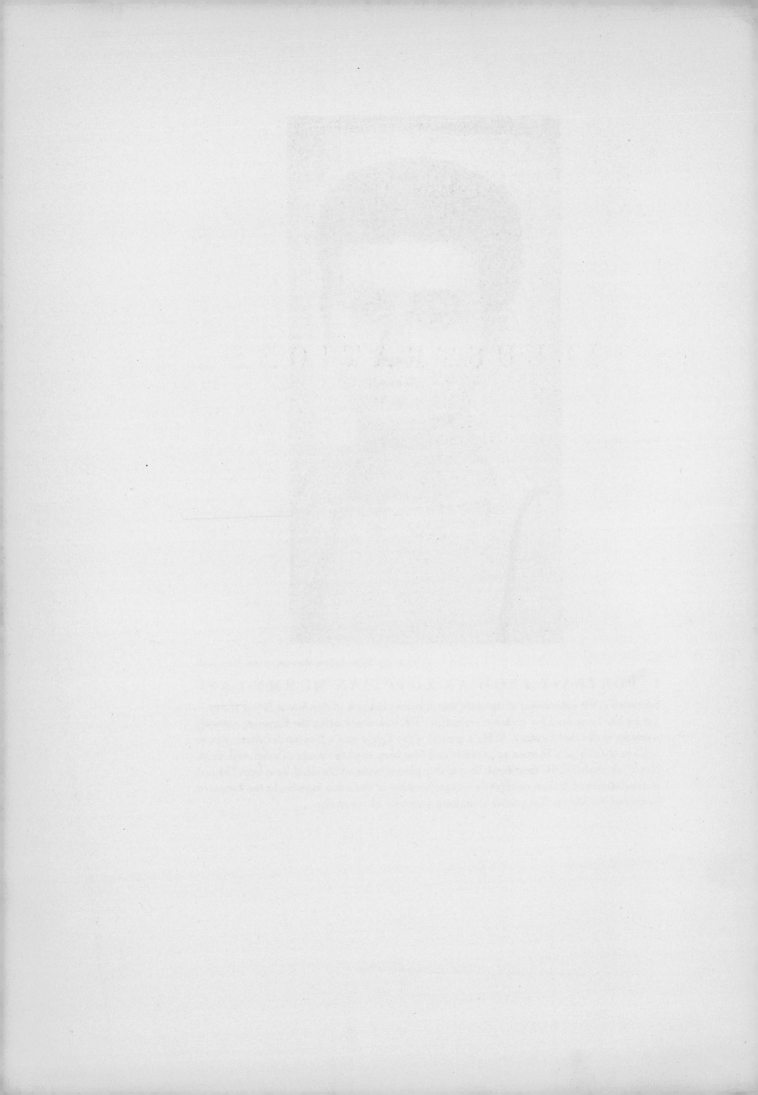

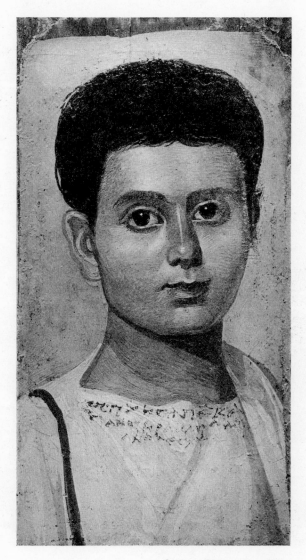

1 PORTRAIT FROM AN EGYPTIAN MUMMY-CASE

So FRESH is the naturalism of the style that it is easy to think of this boy as living today—but he has been dead for eighteen centuries! The task confronting the Egyptian painter, working in the 2nd Century A. D., a period when Egypt was a Roman province, was to achieve as faithful a likeness as possible and thus keep alive the image of a beloved child. Hence, the naturalistic treatment. In our day photographs of the dead have been framed in tombstones of Italian cemeteries—manifestation of the same impulse in the bereaved as moved the ancient Egyptians in making portraits of mummies.

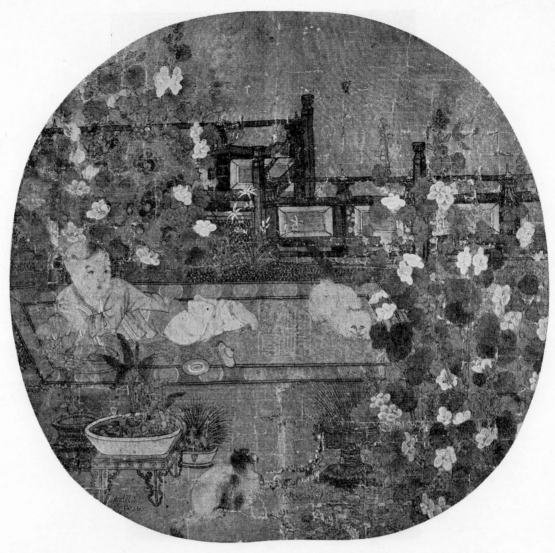

CHINESE PAINTING, SUNG PERIOD (10TH CENTURY)

2 CHILD, DOG AND CAT AT PLAY AMONG
THE FLOWERS

PAINTED ON SILK, fan-shaped, with delicate paints, as soft as those on Sung pottery, combined with the soft red of old Chinese lacquer. The colors smoothly blend on the silk's surface. The artist has not striven to convey space or depth but has concentrated on achieving an unusual harmony of colors befitting the playfulness of the scene. No word will do for the balance of the composition of child and animals, flowers and fence in the background but—serene! *Courtesy Museum of Fine Arts, Boston*

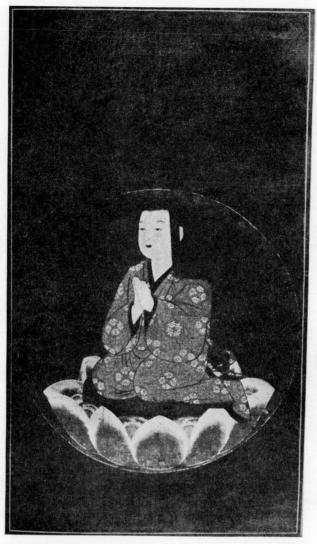

JAPANESE (14TH CENTURY) *Collection of Baron Ino Dan*

3 KŌBŌ-DAISHI AS A CHILD

THE CHILD HERE DEPICTED grew up to become the founder of the Shingon sect of Buddhism. Kōbō-Daishi, who was also known as Kukai, lived from 774 to 835 but this portrait was not painted until five centuries after his death. It is in the form of a "Kakemono," an unframed panel of silk mounted on brocade which is hung on the wall. The custom still current in Japan is, after a painting has been on view for a certain time, to roll it up and replace it by another Kakemono.

Remarkable is the artist's intense concentration upon the figure. There is nothing around that relates it to reality; even the lotus flower on which he kneels serves no realistic purpose but must be considered as a symbol. The whole conception bears a certain resemblance to Byzantine paintings of the same century.

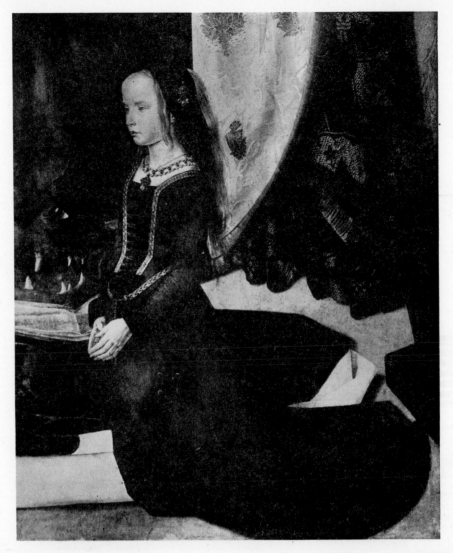

HUGO VAN DER GOES *Courtesy Metropolitan Museum of Art, New York*

4 DAUGHTER OF TOMMASO PORTINARI

A DETAIL from a wing of van der Goes' famous Portinari Altar, this is one of the earliest portraits in the history of Northern European painting. Painted in Bruges, commissioned by Tommaso Portinari, a representative of the Medici banking house in that city, this magnificent work is said to have been responsible for the increasing interest on the part of Italian painters in the technique of oil painting. It is an important link between Northern and Italian painting and one exemplifying the commerce of the time between cities in Flanders and Italy. Designs for many Flemish tapestries were created in Italy by Italian artists and thus the interplay of the two cultures upon each other becomes understandable. At this time portraiture had only gradually begun to develop. On the great altar pieces actual portraits begin to appear of the donor and his family depicted in roles of pious and devoted bystanders. The facial rendering of the little Portinari girl is exquisite, but equal attention is given to the luxurious tapestries in the background, to the jewels which adorn her throat and hair, to the elegance and wealth of her costume.

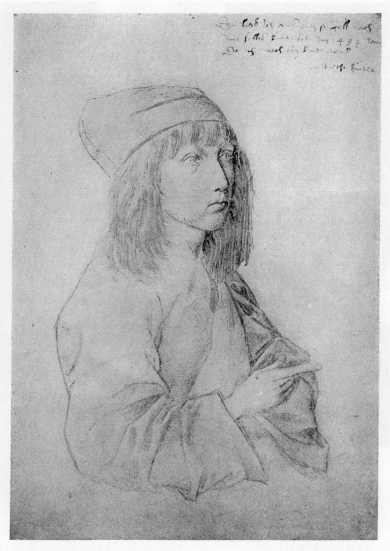

ALBRECHT DURER *Courtesy Metropolitan Museum of Art, New York*

5 SELF PORTRAIT AT THE AGE OF THIRTEEN

THE SELF PORTRAIT of a child—a rare phenomenon indeed. At the tender age of thirteen Dürer gave eloquent proof that he had in him the makings of one of the world's greatest masters of drawing. Already he displayed accomplished technical skill, a mature distinction of style, and, what is more, a striking power of self-observation. With a keen eye for the essential, he disdains all adornments and flourishes, rendering only what is vital and fundamental to the portraiture.

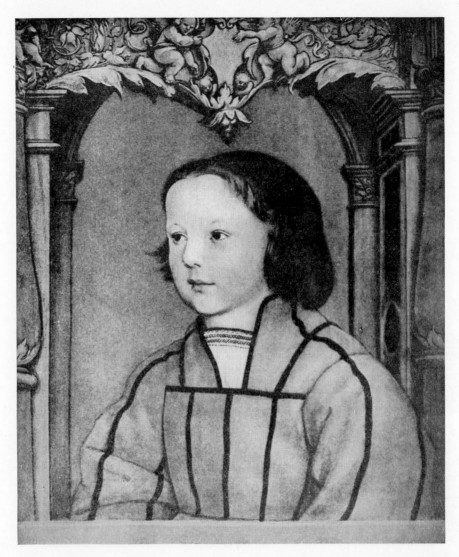

AMBROSIUS HOLBEIN *Photo by Jo Jonas, New York City*

6 LITTLE BOY

DURING THE PERIOD in which this little boy was painted, the spirit of the Renaissance had begun to manifest itself in the North. Here we have a real portrait, a painting in which the child itself is the center of interest. Executed by the older brother of the more famous Hans Holbein, it is exactly the kind of painting the merchant class of Switzerland and Germany admired and respected, a perfect example of the bourgeois influence on art.

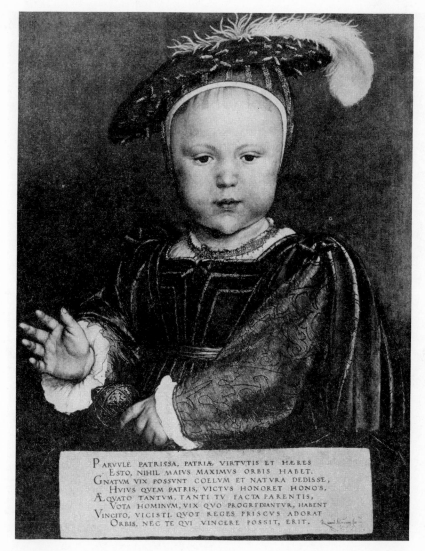

PARVVLE PATRISSA, PATRIÆ VIRTVTIS ET HÆRES
ESTO, NIHIL MAIVS MAXIMVS ORBIS HABET.
GNATVM VIX POSSVNT COELVM ET NATVRA DEDISSE,
HVIVS QVEM PATRIS, VICTVS HONORET HONOS.
ÆQVATO TANTVM, TANTI TV FACTA PARENTIS,
VOTA HOMINVM, VIX QVO PROGREDIANTVR, HABENT
VINCITO, VICISTI. QVOT REGES PRISCVS ADORAT
ORBIS, NEC TE QVI VINCERE POSSIT, ERIT.

HANS HOLBEIN THE YOUNGER *Courtesy National Gallery of Art, Washington, D. C.*

7 EDWARD VI AS PRINCE OF WALES, 1538

COMPARE THIS PAINTING by the younger Holbein with the boy's portrait by his elder
brother, Ambrosius Holbein, and you will at once be struck by its refinement which
almost borders on sophistication. This German painter, who was commissioned to portray
most of the personages at Henry VIII's court, possessed skilled draftsmanship as well
as exquisite taste—a combination only few German artists could boast. This painting of
the heir to the throne was presented to King Henry VIII as a New Year's gift in 1539.
The boy's resplendent crimson dress, his mantle of gold brocade and golden rattle well
befit his exalted rank and yet do not mar the fresh loveliness of this fourteen months old
child. This single example of his work eloquently supplies the reason for Holbein's
position of favorite at the English Court.

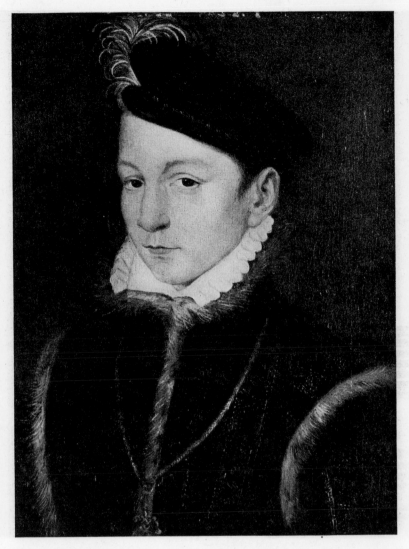

FRANÇOIS CLOUET *Courtesy Metropolitan Museum of Art, New York*

8 CHARLES IX OF FRANCE AS A BOY

THIS YOUNG PRINCE grew up to be the king whose reign was made forever infamous by
St. Bartholomew's Night, that 24th of August, 1572, when thousands of Huguenots were
massacred in Paris. One senses in this picture the nerve-racking pressure exercised
on the boy by his domineering mother, Catherine de Medici, and the various rival factions
of the Court. The sad expression of his eyes, his fine, sensitive nose and weak mouth seem
to forbode his tragic early death.

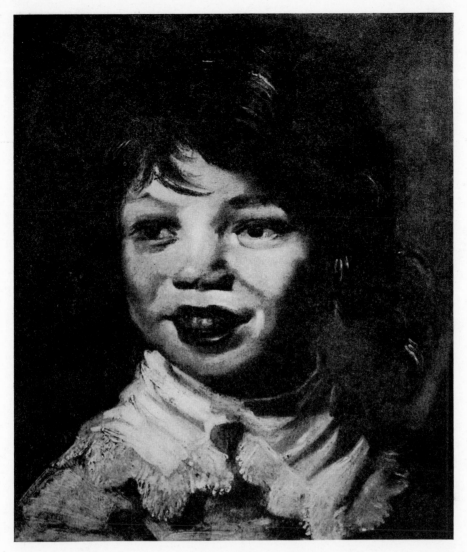

FRANZ HALS *Courtesy Metropolitan Museum of Art, New York*

9 HEAD OF A GIRL

ALTHOUGH THIS CHILD lived at about the same time as the sons of Rembrandt and Rubens, she is altogether another type: a child of the streets—whose mercurial joviality is in marked and intense contrast to the restraint and dignity of the youth of both Court circles and bourgeoisie. With broad and fluid strokes of the brush, with an almost startling directness, Hals has captured a fleeting expression of fresh and brazen glee that is unforgettable. He may indeed be called one of the forerunners of modern Impressionism.

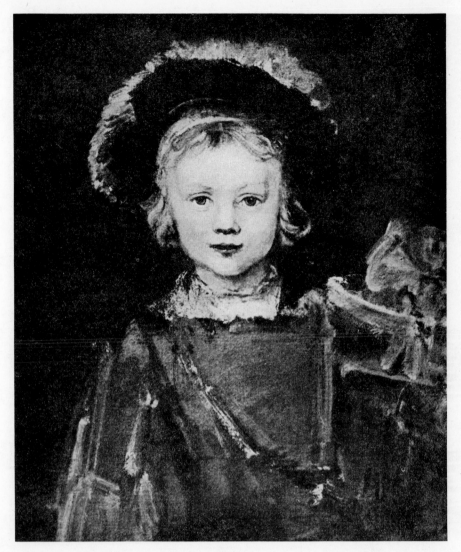

REMBRANDT HARMENSZ VAN RIJN *Photo by Jo Jonas, New York City*

10 TITUS, 1648

PAINTED IN 1648, this portrait through error was for over two centuries entitled "Prince William I of Orange-Nassau." Experts later proved it to be a picture of Rembrandt's own son, Titus. During this period the artist was a prosperous, respected member of society, and the Dutch citizens considered it an honor to be painted by him. The happy little "prince" who looks out of this painting is a striking illustration of the degree to which the mood of the artist can be projected on the image of the sitter. Compare it with the painting, on the next page, made seven years later.

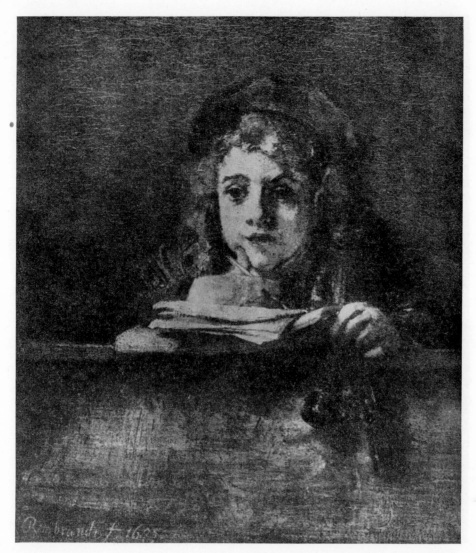

REMBRANDT HARMENSZ VAN RIJN

11 TITUS, 1655

Was Titus really so serious, so absorbed in thought, when this painting was made, or does the sombreness of the picture mirror the change in Rembrandt's fortunes? The characteristic Rembrandt contrast between light and shadow dramatically interprets the changed personality of the child we have seen on the preceding page.

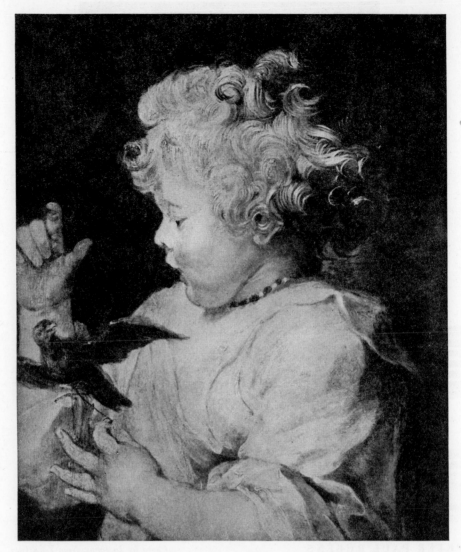

PETER PAUL RUBENS *Courtesy Metropolitan Museum of Art, New York*

12 NICOLAUS RUBENS, ABOUT 1620

THERE CAN BE little doubt that this was a labor of love. The treatment of the hands, the modeling of the nose and cheeks, the attention to curls and eyelashes, the delicacy of the flesh tones, all bespeak parental pride. The impress of the great Rubens is in every brush-stroke. His close contact with almost all European courts, the versatility he acquired in his many travels on diplomatic missions, find a reflection in his art, truly the finest flourishing of the Baroque period in Flemish painting.

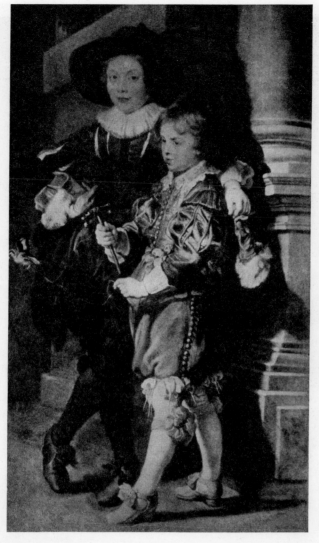

PETER PAUL RUBENS *Photo by Jo Jonas, New York City*

13 ALBERT AND NICOLAUS RUBENS, ABOUT 1626

To OUTWARD APPEARANCES these are princes of the blood. The costly and resplendent material of their clothing, the magnificence suggested in the background, reflect the insatiable ambitions of their father, the courtier, painter and diplomat. Nicolaus retains the full underlip of his baby-hood, and, curiously enough, a bird again occupies his interest. Albert appears a worldly young gentleman, nonchalantly dangling a fur-trimmed gauntlet. His raised eyebrows and slightly closed eyes lend his expression an air of precocious sophistication. Rubens in this picture reveals acute psychological understanding for it is not difficult to tell which of these youngsters will grow up to be an active man of affairs and which will always be a dreamer.

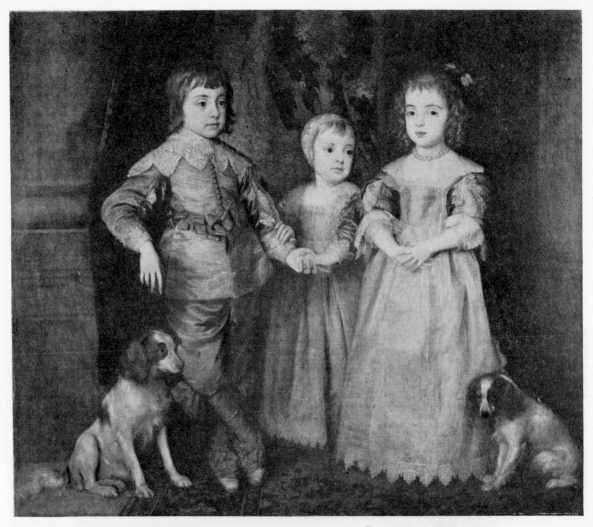

ANTONY VAN DYCK *Courtesy Metropolitan Museum of Art, New York*

14 THE CHILDREN OF CHARLES I OF ENGLAND

ONE MIGHT CALL Van Dyck a traveling Court painter, and among the nearly three hundred portraits of Royal and exalted personages which his fertile brush produced, those of children are outstanding. Faithful portraiture, acute psychological observation and a pronounced cognizance of social position and distinction are blended into an harmonious, well balanced work of art. In this expertly arranged picture Van Dyck makes no pretense of having caught the children unaware but shows them fully conscious of posing for a picture befitting their rank and station.

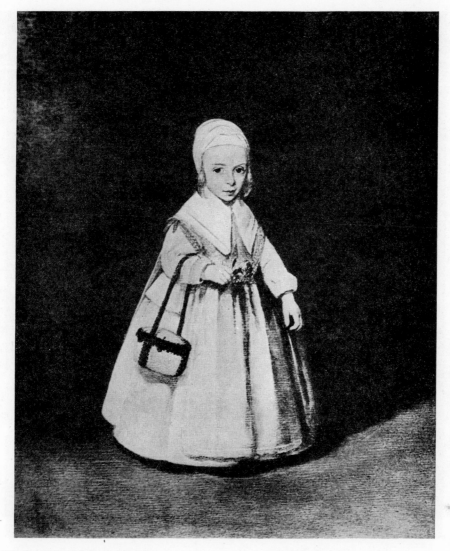

GERHARD TER BORCH *Photo by Jo Jonas, New York City*

15 HELENE VON DER SCHALKE

THIS IS how a wealthy Dutchman of Ter Borch's time liked to have his child painted. The picture is a significant one because it gives us a revealing glimpse of the social standards and ambitions of the solidly prosperous Holland of that era. The artist is compelled to represent the child as the little lady, formally and expensively dressed, her posture uncomfortably stiff. There is palpable affectation and pretentiousness in the whole arrangement, and the child does not impress the spectator as being at all happy about it.

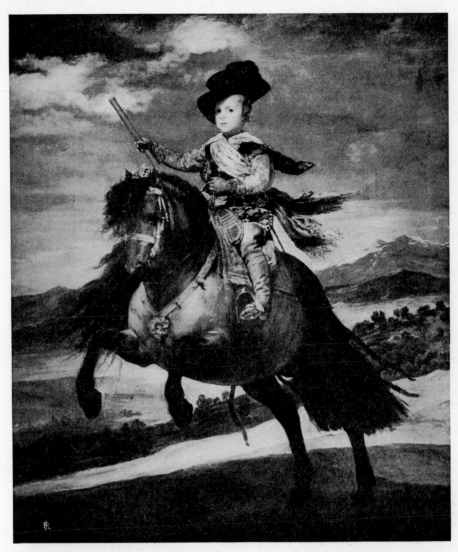

DIEGO VELASQUEZ *Courtesy Metropolitan Museum of Art, New York*

16 DON BALTASAR CARLOS ON HORSEBACK, 1631

THIS PICTURE proves anew that Velásquez was a fashionable Court painter as well as a
great artist in his own right. In this portrait he succeeded in harmonizing and reconciling
two contradictory aspects: the prince's dignity of rank and his boyishness. He is por-
trayed in a field marshal's uniform, his pose proud and commanding, in accordance
with the pomp and ceremonial of the Court of Spain. But who will not also see in him
the boy hugely enjoying his ride, sitting this prancing horse like an accomplished
equestrian though his age would fit him more for the hobby horse.

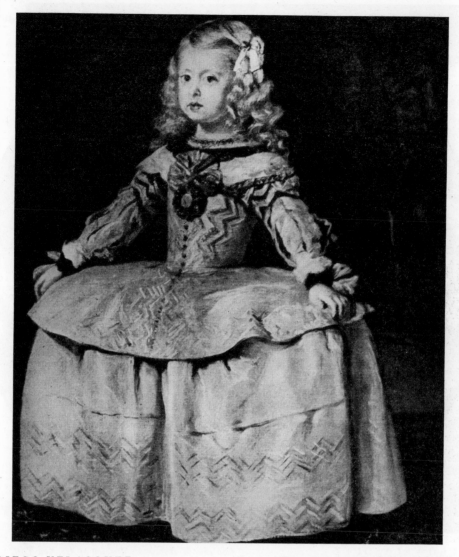

DIEGO VELASQUEZ *Courtesy Metropolitan Museum of Art, New York*

17 THE INFANTA MARGARITA, ABOUT 1656

ALREADY EVERY INCH A PRINCESS, this young girl is not just striking an adult pose. She displays every sign of a mature personality and full consciousness of her position in the world. The insignia of her royal rank, the glittering jewels and rich brocades seem an integral part of her.

This picture, one of the many which Velásquez painted of this princess, has additional historical interest in the fact that apart from the portrayal itself there are implied the haughtiness, the pride, pomp and circumstance of the Spanish Court.

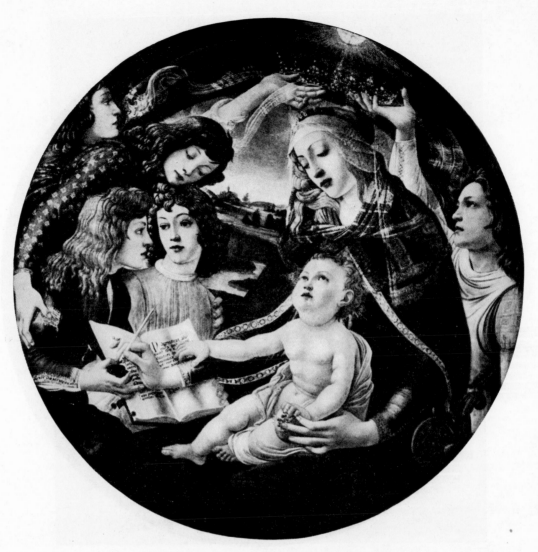

SANDRO BOTTICELLI

18 THE "MAGNIFICAT"

THE ARTISTS OF THE RENAISSANCE early discovered the adult individual but it took them almost a century to discover the characteristics of the child. The Christ Child and the angels of their religious paintings remained divinely aloof, bearing only a remote resemblance to actual children. Only toward the end of the fifteenth century did the child come into its own as a subject of creative art.

This painting by Botticelli is distinguished not only by its wonderfully balanced composition but also by the exquisite care which the artist expended on the numerous realistic details of the children's figures. Here Christ and the Angels are live and real children, their postures and movements typical, and suggestive of varied, living personalities.

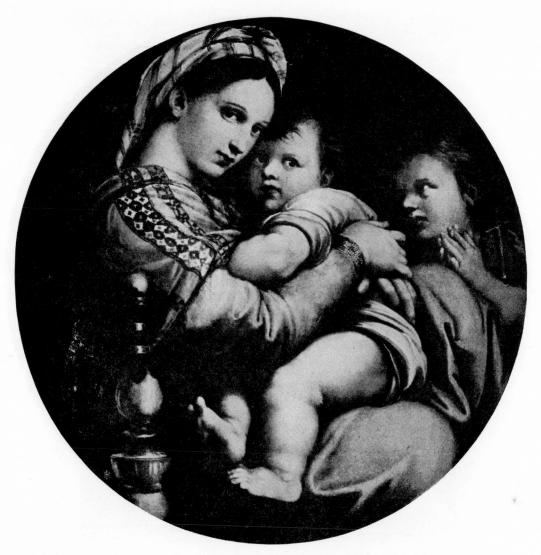

RAPHAEL SANZIO *Courtesy Metropolitan Museum of Art, New York*

19 MADONNA OF THE CHAIR

RAPHAEL PAINTED many pictures of the Madonna and Child but none of the Christ Child alone. This is one among the number in which Raphael depicted Christ and the Infant Saint John with the closest resemblance to living children. The natural grace of their postures is admirably adapted to the round canvas.

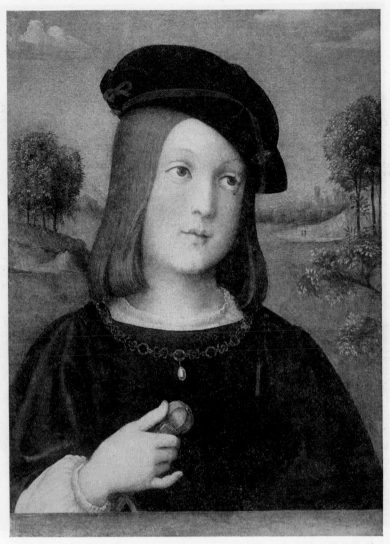

IL FRANCIA (FRANCESCO RAIBOLINI)

20 FEDERIGO GONZAGA, 1510

ONE IS READILY TOUCHED by this sympathetic portrait of young Federigo Gonzaga, who, twenty years later, was created Duke of Mantua by Emperor Charles V. The painting has an intriguing history which involves many powerful families of the High Renaissance. It was ordered by Federigo's mother, Isabella d'Este, one of the leading patrons of arts and letters in her time, when Pope Julius II demanded that she send her son as a hostage to the Papal Court. The expression on Federigo's face, the landscape in the background, the whole atmosphere, suggest that the occasion on which this portrait was painted was not an auspicious one.

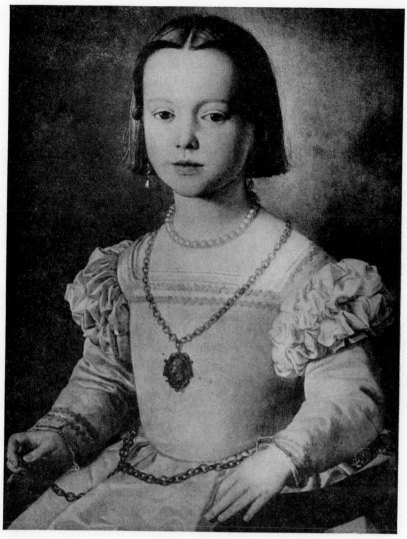

AGNOLO BRONZINO *Courtesy Metropolitan Museum of Art, New York*

21 PORTRAIT OF BIA DE' MEDICI, ABOUT 1540

WE FIND IN THIS PAINTING by Bronzino a worldliness of atmosphere and a suggestion of
courteous deference, unusual in the portrait of a child. But their presence does not over-
whelm the charm of the child's personality. Bia is not a miniature adult but a real child
and the sparing use of details, the simplicity of composition, safeguard that childishness.
The locket suspended from her necklace contains a portrait of her illustrious father,
Cosimo I de' Medici.

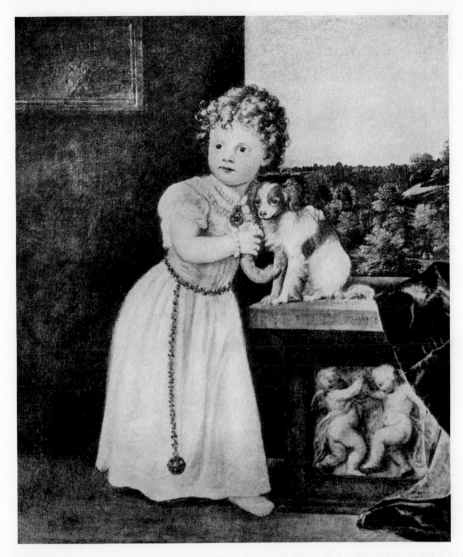

22 THE DAUGHTER OF ROBERTO STROZZI, 1542

THIS PORTRAIT of the daughter of Roberto Strozzi, who belonged to a famous family of the Italian Renaissance, is a masterpiece of deftly balanced composition. Landscape and architectural background help to focus the attention on the expressive features of the little girl. The enchanting harmony of colors, an immeasurable element in the beauty of this painting, is unfortunately lost in the reproduction. Despite its outstanding artistic qualities, however, it has not the same dramatic brilliance as Titian's portraits of adult personalities: Popes, Venetian Doges, or the Emperor Charles V.

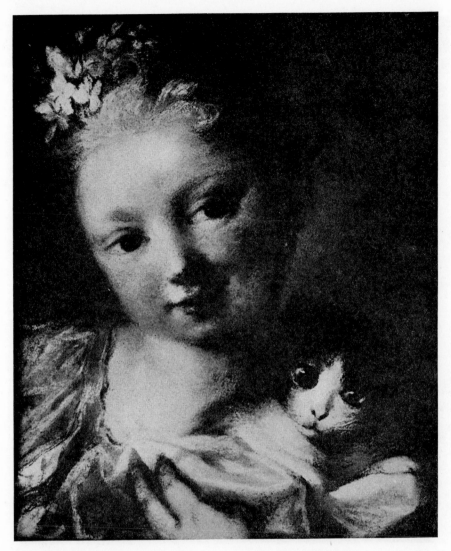

ROSALBA GIOVANNA CARRIERA *Courtesy Metropolitan Museum of Art, New York*

23 LITTLE GIRL WITH CAT

WE FIND ONLY FEW CHILDREN in the galaxy of exalted and famous personalities portrayed
by this itinerant Italian woman painter. And yet she was the most famous pastel painter
of her day and could have employed effectively the tender shades and smooth transitions
of her medium to depict the freshness of a child's complexion. This painting impresses
us almost as a still-life, for the artist was not concerned with the personality of the
child. Rather, by devoting equal attention to the cat, she shows that her principal interest
was in texture and tonal values.

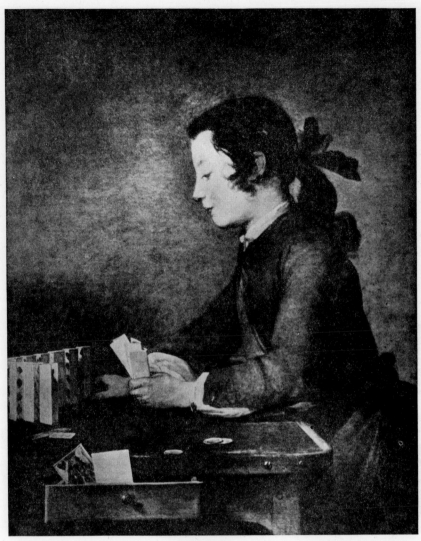

JEAN-BAPTISTE SIMEON CHARDIN

24 THE HOUSE OF CARDS

CHARDIN IS THE ONLY bourgeois painter of the French Rococo period. This painting of a boy building a house of cards is distinguished by its utter simplicity of composition, the figure drawn in clear profile. The subtle finesse of Chardin's smooth paint, which is typical also of his still lifes, achieves an atmosphere of childish concentration which excludes the outer world.

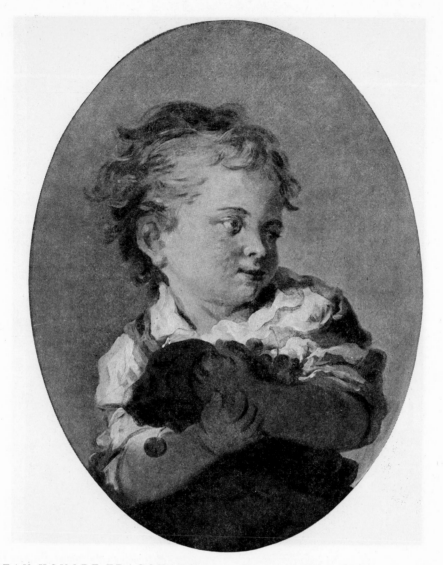

JEAN HONORE FRAGONARD *Courtesy of Wildenstein & Co., Inc., New York.*

25 BOY WITH CHERRIES

ONLY THE SKILL which the great possess will significantly capture a fleeting expression, arrest a trivial movement, fix the quick passage of emotions in a human face. By exploiting his medium to the full, Fragonard has here performed that feat: recording a transient moment in which we see the child's joy over the cherries in his hands, the greediness of childhood. Particularly in the eighteenth century did French painters like to record such momentary expressions.

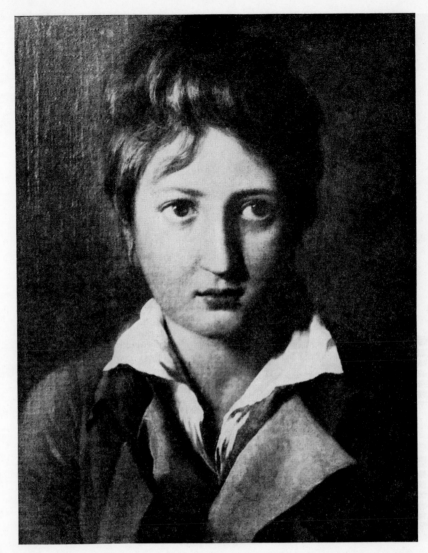

JACQUES LOUIS DAVID

26 YOUTH

DAVID IS GENERALLY RECOGNIZED as the founder of the classical revival in French painting. "Art has to serve an idea and not life" directed the composition of his great historical paintings. True to this motto he valued his portraits least among his works. Today we are inclined to reverse his judgment and to prefer his portraits of Pope Pius VII or Madame Récamier to his monumental historical works. This portrait of a youth proves that David was not always a classicist but anticipated the romantic feelings which became dominant in the next generation. In this work he combines the emotional values of romanticism with the noblesse of classical attitude.

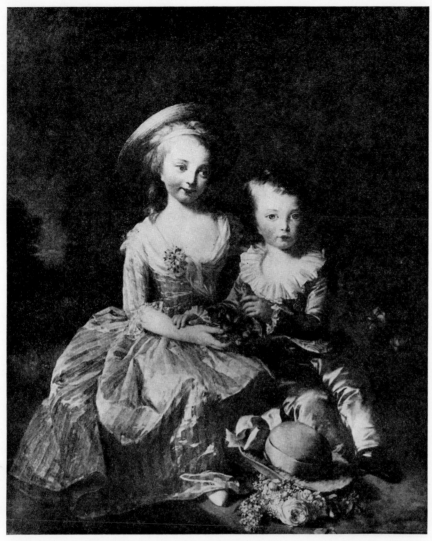

MARIE LOUISE ELISABETH VIGEE-LE BRUN

27 MADAME ROYALE AND HER BROTHER
LE DAUPHIN, 1784

MARIE VIGEE-LEBRUN had two favorite subjects for her portraits, the Royal Family and her own, and it is hard to say which of the two she preferred. We find an abundance of portraits of herself with her daughter and of Marie Antoinette, Louis XVI's Queen, with her children. Even if we were not aware of the terrible fate that was in store for these two children, the heir to the throne of France and his sister, we could not but be touched by this painting in which one senses the genuine warmth and compassion of a woman and mother. With its emotional appeal and exquisite execution this painting well exemplifies the high standards of French portrait art in the eighteenth century.

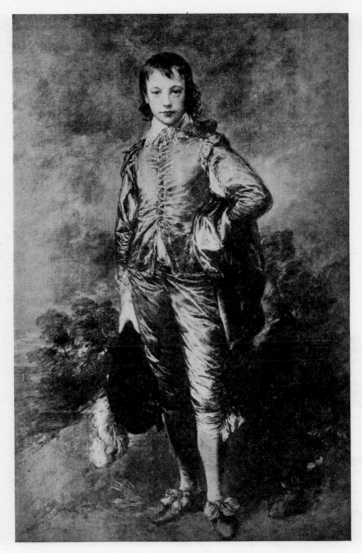

THOMAS GAINSBOROUGH *Courtesy Metropolitan Museum of Art, New York*

28 BLUE BOY

THAT THIS BOY is an aristocrat from head to foot is evident in every brush stroke. Nobility
is the keynote in this painting, and each detail, the distribution of light and shadow, the
remarkable shading of the blue and green color tones, brings it into further evidence.
Pride and consciousness of class permeate the atmosphere and the boy is much more a
representative of his caste, the heir of many noble generations, than an individual
youngster. Notice the influence of Velásquez and Van Dyck; yet how much more live and
real were their portraits even when they depicted royalty.

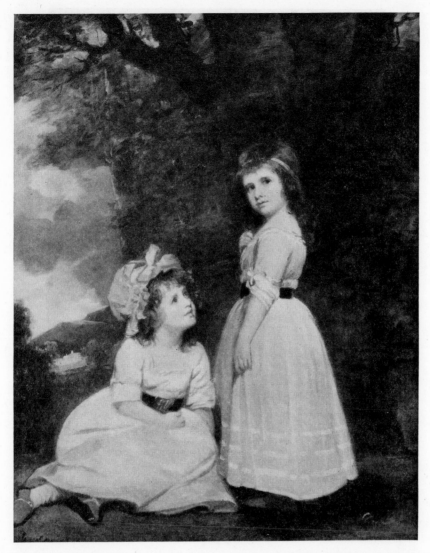

GEORGE ROMNEY *Courtesy Huntington Library, San Marino, California*

29 THE BECKFORD CHILDREN

THIS IS ONE of the few English child paintings of the period which rises above the prevailing conventions. It does more than merely idealize the subjects and convey their social distinction in a tasteful and decorative manner. The atmosphere of sweetness and innocence which it was customary to find in a child's portrait has been avoided and the painter has achieved real child-individuality in his portrayal.

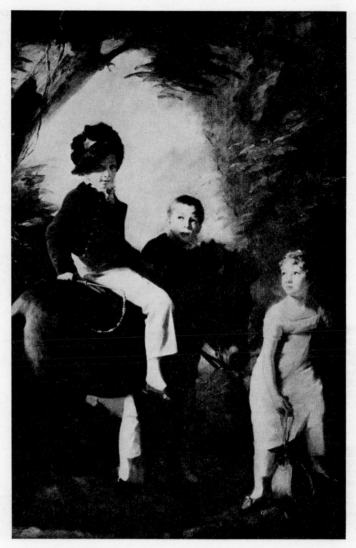

SIR HENRY RAEBURN *Courtesy Edward Stephen Harkness, New York*

30 THE DRUMMOND CHILDREN

IN THIS, as in the majority of English child paintings of the period, the poses and movements lack the spontaneity and natural exuberance of children at play. One feels that they are accustomed to sitting for painters; that it is but the fulfillment of one of the many social duties imposed by their position. And the result is a hothouse prematurity of grace and charm, which in combination with the then prevailing tastes in painting makes for sentimental artificiality.

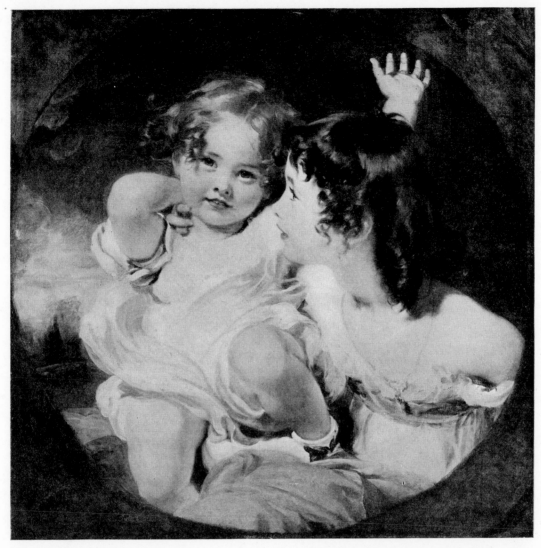

Courtesy Metropolitan Museum of Art, New York

31 THE CALMADY CHILDREN, 1824

THIS PICTURE WAS at first entitled "Nature," and it is indeed more than just a painting of two children. Going far beyond a mere portrayal of two little aristocrats possessed of charm and breeding, Sir Thomas made them symbols of the ideal nature of the child.

Painter in ordinary to King George III, knighted for his services, he was further acclaimed and honored for this painting which upon its exhibition in Paris brought him the Knighthood of the French Legion of Honor.

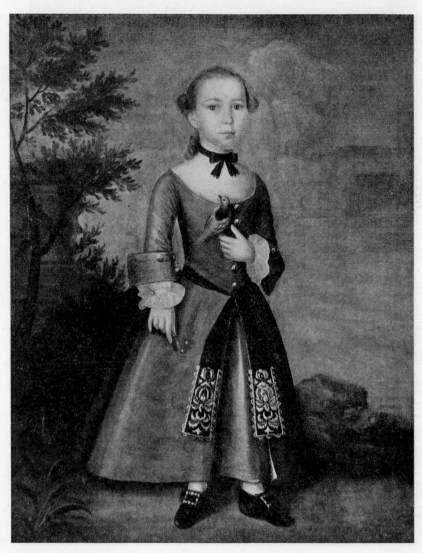

32 PORTRAIT OF HIS SON JAMES BADGER

ONE CANNOT HELP being amused at this example of American pre-revolutionary portraiture. In painting his son, Badger observed many of the conventions of European artists. Notice the classic ruin in the background, the bird perched on the hand, the painstaking attention to embroidery, buttons and shoe-buckles. Badger by trade was a glazier and house painter, but in time came to be one of the first professional portraitists in this country. Granted that this portrait is pretentious on one hand and naive on the other—the latter being a quality common to most folk art—it has a genuineness which makes it a remarkably interesting example of early American painting.

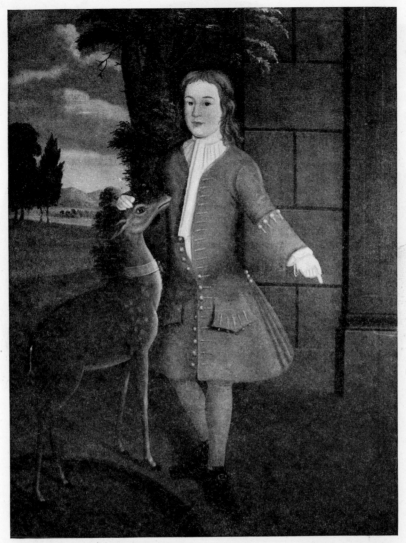

EARLY AMERICAN, ANONYMOUS *Courtesy Brooklyn Museum, Brooklyn, New York*

33 JOHN VAN CORTLANDT, ABOUT 1730

THIS EARLY AMERICAN PORTRAIT depicts a member of one of the country's oldest families. The helpless cardboard faun and the basin in the left foreground recur again and again in this painter's work, constituting almost a trademark. Together with the awkward, stilted boy they make a charming composition. One can see that the artist tried his very best to satisfy his client's demand for a truly imposing picture.

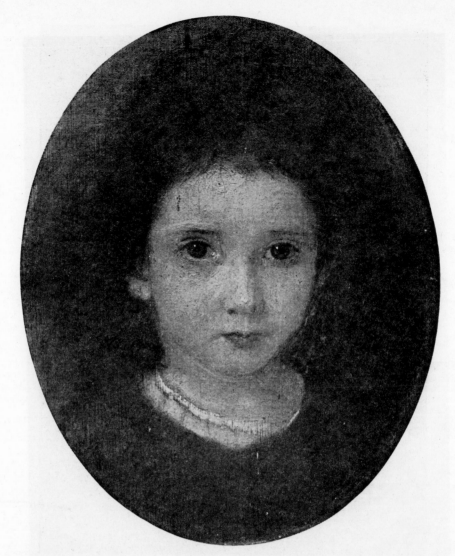

WILLIAM PAGE *Courtesy Metropolitan Museum of Art, New York*

34 PORTRAIT OF A GIRL

ONE OF THE BEST AMERICAN PORTRAITS of the nineteenth century. The artist's studies in
Rome matured his sympathetic imagination and lent romantic animation to his work.
Using the simplest of means, no ornate background, no rich profusion of costume, no
hallmark of social status, Page has captured an individual in this poetic, dreamy child.

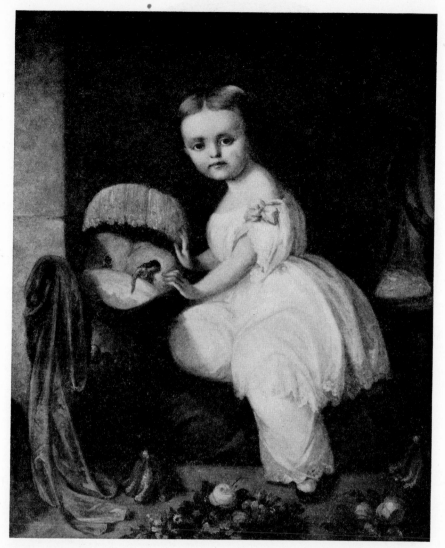

LOUIS LANG *Courtesy The New York Historical Society, New York*

35 JULIA AUGUSTA MEAD, ABOUT 1845

THE DECOROUS PLATITUDES and restrictions of the early Victorian era are mirrored in the portrait of this girl. Just as in bourgeois seventeenth century Holland, it was fashionable to depict the child as a miniature adult. The painter had made good use of the amusing contrast between the nursery paraphernalia and the staid and serious bearing of the child.

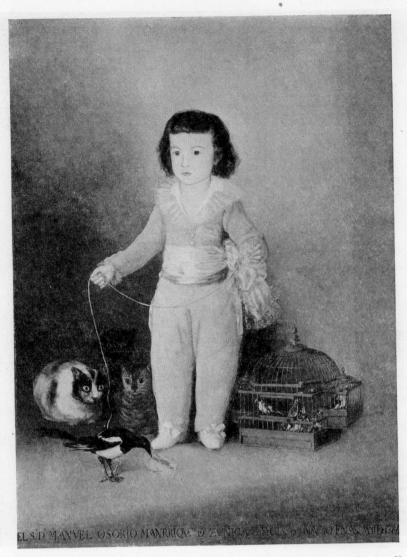

FRANCISCO GOYA *Courtesy The Bache Collection, New York*

36 DON MANUEL OSORIO DE ZUNIGA, 1784

THE THREE WATCHFUL CATS and the bird holding in its beak an engraved card with the artist's signature make first claim upon our attention. But the string with which the magpie's foot is tied leads our eyes gradually in the direction of the child himself, whose face has the same expression of unreality as the group of animals. As is often the case with portraits by this great Spanish artist, we cannot escape the feeling that he sought to embody a symbolism whose meaning however escapes our visual apprehension.

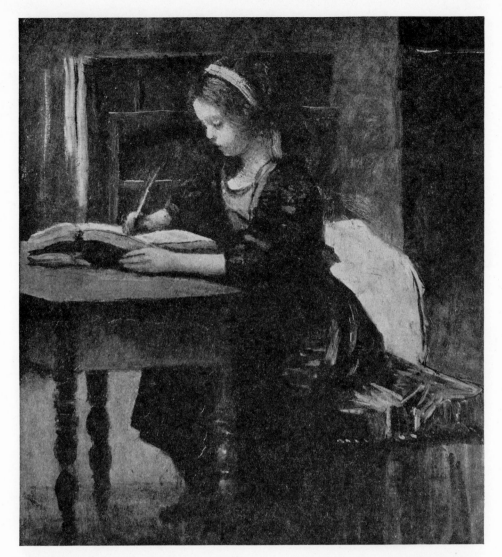

JEAN BAPTISTE CAMILLE COROT *Collection Percy Moore Turner, London*

37 LITTLE GIRL STUDYING, BETWEEN 1850-1860

AMONG THE GREAT FRENCH PAINTERS of the nineteenth century, Corot is one of the first.
Although his world-wide reputation rests largely on his smooth and misty landscapes—
of which there have been a great number of falsifications—Corot gradually begins also
to be appreciated as a figure and portrait painter. The delicacy of his colors, the smoke-
like transition from shade to shade, are also the main elements of his figure painting.
Corot continues the tradition of solid craftsmanship which has prevailed in French por-
traiture since the eighteenth century.

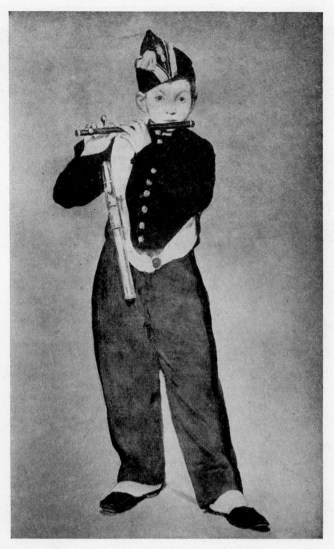

EDOUARD MANET *Courtesy Metropolitan Museum of Art, New York*

38 THE FIFER

HERE IS A BOY and a budding soldier marching toward manhood, embodying all that is youthfully militant in his people. Yet this resolute determination is only skindeep, and underneath it is a layer of self-consciousness which the artist brings home to us by masterly contrasts of colors and shades, striking a balance between military bravado and innate childlike charm. Dreaming of a hero's exploits, he is still very much a boy.

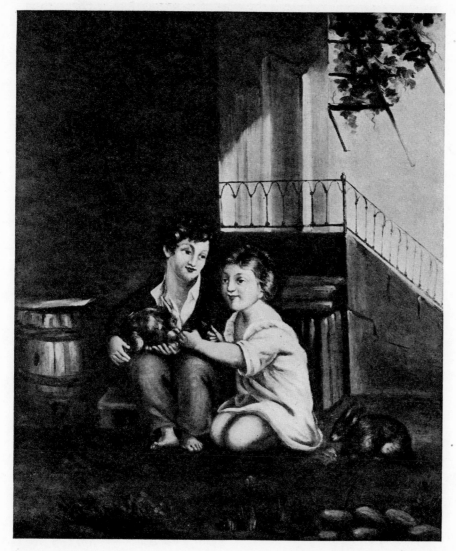

PAUL CEZANNE *Courtesy Bignou Gallery, New York*

39 THE TWO CHILDREN

LOOKING AT THIS PICTURE one can hardly believe that it was Cézanne who painted it;
so diametrically is it opposed to all that he stands for in the world of art. Early in his
"academic period," however, the influence of the Mid-Victorian era over the young
artist was still strong enough to make him paint dull and stiff creatures like these. A
travesty of the natural freshness and loveliness of children, this painting is an unholy
mixture of bourgeois sentimentalism and decaying academism. What could be a more
untypical expression of the genius of a man who has been justly hailed as pioneer of
modern painting?

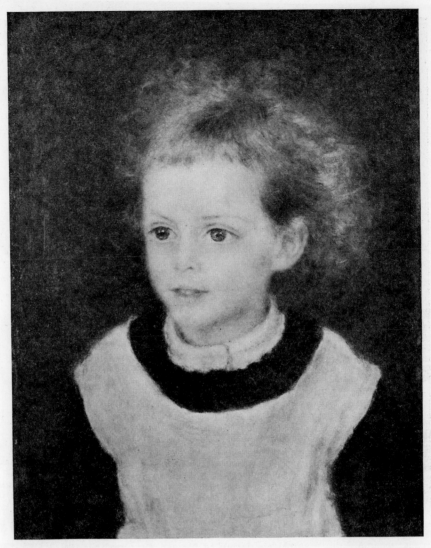

AUGUSTE RENOIR *Courtesy The Museum of Modern Art, New York*

40 LITTLE MARGOT BERARD, 1879

THE GREAT FRENCH IMPRESSIONISTS have often been criticized for their primary concern with visual values, their over-emphasis on texture. You have only to look at the unforgettable expression of this child's eyes to realize how little justified such a sweeping generalization is. Their brilliant rendering of textures and surfaces, their acute observation of minute variations of color and light, sharpened the Impressionists' sensibilities and deepened their aesthetic and psychological insight.

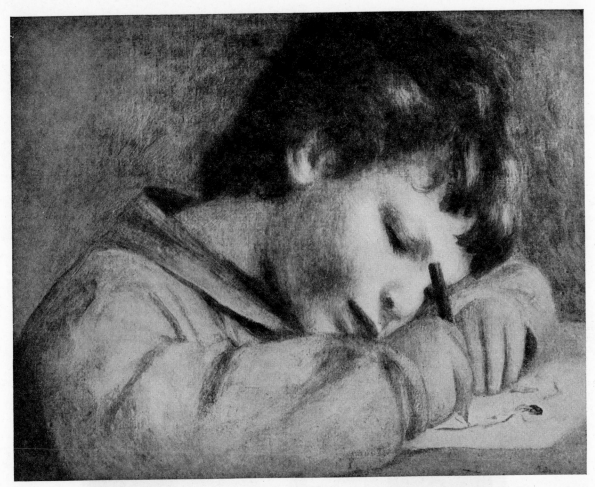

AUGUSTE RENOIR

41 LITTLE BOY WRITING, 1888

IN ADMIRING RENOIR'S PAINTINGS we are likely to give little thought to the superior drafts-manship which gave a solid foundation to his art. He observed with a keen eye and conveyed his impression by means of a few bold and striking lines. The very essence of childlike endeavor is captured for us in this sketch of a child trying to write.

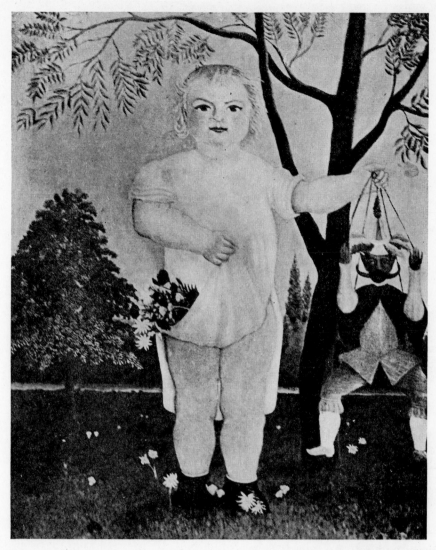

HENRI ROUSSEAU

42 POUR FETER BEBE, 1903

THE FLAT PATTERN of this portrait and its primitive style remind us of a child's painting. Rousseau was a customs officer who had never received any training in the arts and did indeed paint with the naive directness of a youngster. He sees this child with the eyes of an equal, as its playmate would see it, and in depicting it uses the primitive symbols of childhood. And yet, despite its curious perspective, the juvenility of the draftsmanship, one cannot deny the forcefulness of this portrayal.

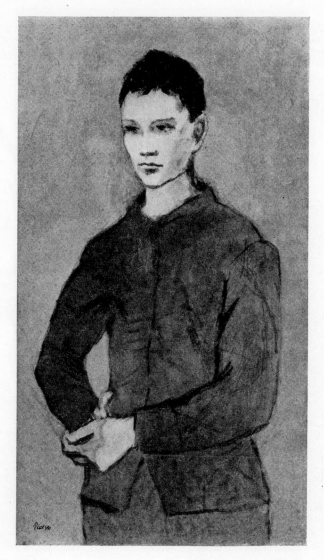

PABLO PICASSO *Collection Edward M. Warburg, New York*

43 BLUE BOY, 1905

THE RESTFUL POISE and melancholy mood of this "Blue Boy" are typical not only of the
artist at this stage of his development but of the general frame of mind at the turn of the
century also, as it found expression in contemporary painting. By visual impact one
grasps the striking changes which the world has undergone since the middle of the
eighteenth century when one compares this "Blue Boy" with its namesake by Gains-
borough. These two paintings placed side by side tell dramatically the story of social
change reflected in creative art.

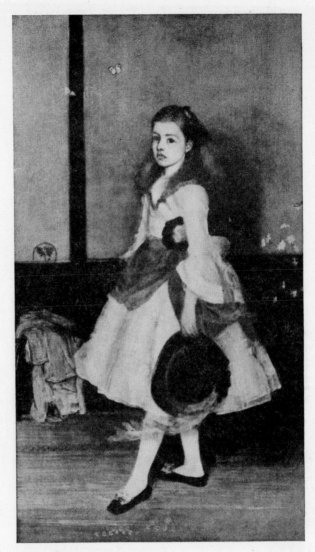

JAMES McNEILL WHISTLER *Courtesy Metropolitan Museum of Art, New York*

44 MISS ALEXANDER, 1872

IN THIS PORTRAIT, one of the many excellent ones which Whistler painted of children, we can see the influence of Velásquez and his splendor; also the inspiration of Japanese art revealed in the careful distribution of spots of color. The harmonious composition achieved by means of a sequence of triangles complements the blend of colors effectively.

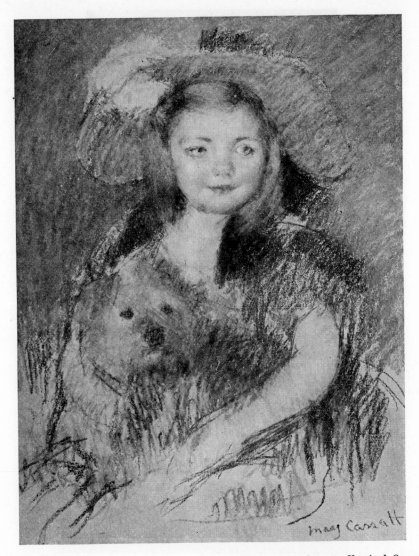

MARY CASSATT *Courtesy Wadsworth Atheneum, Hartford, Connecticut*

45 CHILD HOLDING A DOG, 1908

MARY CASSATT WAS an American who studied and painted in Paris, in close proximity to the great French Impressionists who strongly influenced her. But over and above that influence a definitely feminine touch is manifest. Her favorite subjects were women and children and her paintings show a sensitive understanding of the mother and child relationship.

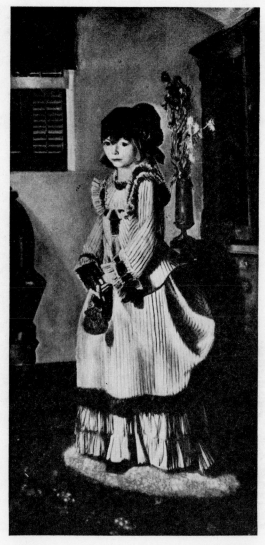

GEORGE W. BELLOWS

46 LADY JEAN, 1924

THIS PICTURE of the artist's younger daughter is a charming illustration of the change which an artistic device may undergo in the course of time. You have seen pictures in which the Dutch masters of the seventeenth century and painters of later schools made their children appear as miniature adults, in artificially grown-up attitudes. Bellows inverts the pattern, playfully using grown-up habiliments to emphasize the extreme youth of the girl. We are even left in doubt whether it was not the child herself who selected this outfit for fun.

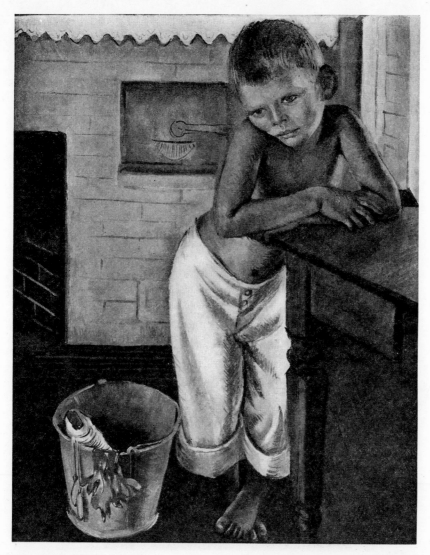

HENRY VARNUM POOR

47 THE DISAPPOINTED FISHERMAN, 1932

THIS PICTURE LEAVES no doubt that the subject is a real boy—with all the disenchantment of a young angler whose sport has been spoiled. Clear cut forms and an expert distribution of space create an effective relationship between the child and his environment. There is no room left: it is physically full and complete also in its deft conveying of a mood. And the means used by the artist are just as sober and realistic as the situation they depict.

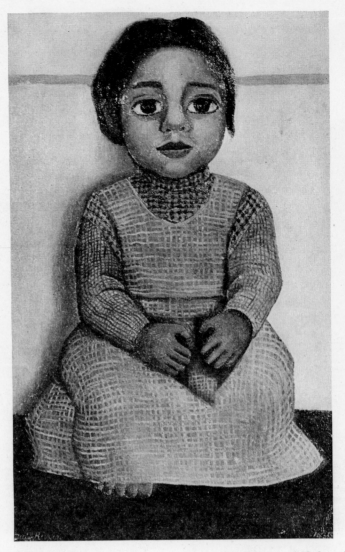

DIEGO RIVERA *Courtesy The Museum of Modern Art, New York*

48 CHILD IN A CHECKED DRESS, 1930

DIEGO RIVERA IS A PRODUCT and protagonist of the creative ability and intuition of Mexican folk art. You may at first think that this painting is the work of an unschooled craftsman, but that impression is erroneous. The expert will at once recognize that its condensed vigor and mute power represent the fruits of a complex and laborious artistic development. Although not executed on a grand scale it has the essential characteristics of a monumental creation. It is, indeed, one of those fine works of art whose full beauty and significance have to grow upon you. Look steadily at the child's eyes, and the peculiar quality of their expression will haunt you for a long time.